S0-BSL-826

Color Mixing
Swatch Book

by Michael Wilcox

The Michael Wilcox
School
of Color
Publishing

Artist Quality products created by Artists

SCHOOL OF COLOR PUBLICATIONS
www.schoolofcolor.com

ISBN 0-9679628-5-4
Text, Illustrations and Arrangement Copyright:
The Michael Wilcox School of Color Publishing Ltd.
Gibbet Lane, Whitchurch
Bristol BS14 OBX
England
Tel: UK 01275 835500
Facsimile: UK 01275 892659
First published 2001

Distributed to the trade and art
markets in North America by
North Light Books
an imprint of F & W Publications Inc
4700 East Galbraith Road
Cincinnati, OH 45236
(800) 289 0963

Scanning and color balance:
Paul Goodman
Planning:
Matthew Brown
Page design and layout:
Michael Wilcox
Finishing:
Maureen Bonas
Paintings
Jeremy Ford
Text:
Michael Wilcox
Publisher
Anne Gardner
Printing:
Imago productions F.E. Singapore
Print coordination:
Emma Bell and Deepa Travers

1

Contents

The swatches were all prepared by mixing color A with color B. The resulting mixes * are shown between these two colors on the top line.

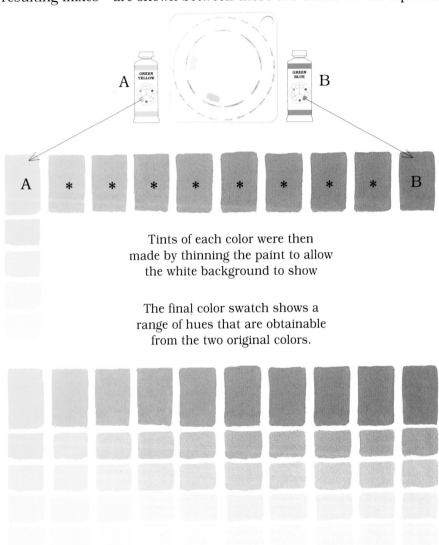

Tints of each color were then
made by thinning the paint to allow
the white background to show

The final color swatch shows a
range of hues that are obtainable
from the two original colors.

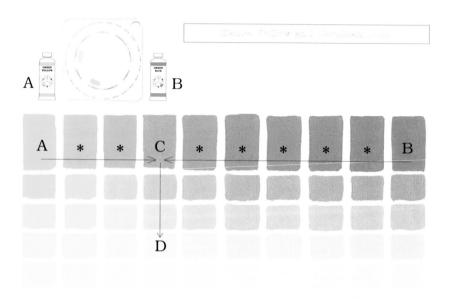

If you wished, for example, to mix color D, simply
mix colors A and B to arrive at C.
Then thin the color until you have D.

The names of the actual colors that you need are
given in the title bar at the top of
the page, in this case Hansa Yellow and Cerulean
Blue have been used.

Conventional color printing is severely limited when it comes to the depiction of
the range of hues available in paint form. Therefore please treat the color mixes
given in this book as a guide rather than as an exact match.
In addition, the colors supplied by the various paint manufacturers vary widely.
It would be impossible to produce such a book which covered all possibilities exactly.

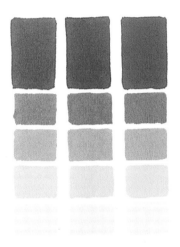 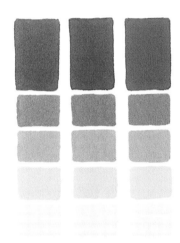

The brightest tints are created when the background lightens the color.

The use of white will always dull and 'cool' a color.

The tints shown throughout this book are produced by thinning the color with a dilutent (water, turpentine etc.) and applying the paint lightly. This approach will give the brightest tint and is applicable to oil paints, acrylics and alkyds, as well as to watercolor paints.

The oil and acrylic painter should perhaps consider this approach rather than, as is usual, only adding white.

When white is added to any color it will dull and 'cool' it. It will also make otherwise transparent paints more opaque and 'chalky'. However, such colors have a very important part to play in all forms of color use. The swatches show only the brighter tints which are available as it is easy to imagine them made slightly duller and 'chalkier though the use of white.

5

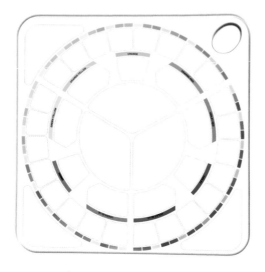

The position of each color used in this book is given on the
Color Mixing Palette developed by the School of Color.
However, it is not essential that you use the palette as any
mixing surface will do. If you do use the palette the diagrams
will help in placing the colors.

CADMIUM RED LIGHT

ORANGE-RED, OPAQUE
LIGHTFASTNESS I: EXCELLENT
P.R. 108
It is suggested that you avoid genuine
Vermilion as an alternative as it can darken
quite dramatically.

QUINACRIDONE VIOLET

VIOLET-RED, TRANSPARENT
LIGHTFASTNESS II: VERY GOOD
P.V. 19
Alizarin Crimson should not be used as an
alternative as it fades when applied thinly or mixed
with white. It also gives poor violets.

CADMIUM YELLOW LIGHT

ORANGE-YELLOW, OPAQUE
LIGHTFASTNESS I: EXCELLENT
P.Y 35
Avoid Chrome Yellow as a possible alternative
as it tends to darken on exposure to light.

HANSA YELLOW LIGHT

GREEN-YELLOW, SEMI TRANSPARENT
LIGHTFASTNESS II: VERY GOOD
P.Y. 3
Other green-yellows will be suitable if they
are lightfast. The most common name will
be 'Lemon Yellow'

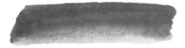

CERULEAN BLUE

GREEN-BLUE, OPAQUE
LIGHTFASTNESS I: EXCELLENT
P.B. 36:1
It pays to use genuine Cerulean Blue as alternatives
are usually inferior imitations.
Check that the pigment is either PB 36:1 or PB35

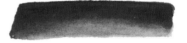

ULTRAMARINE BLUE

VIOLET-BLUE, TRANSPARENT
LIGHTFASTNESS I: EXCELLENT
P.B. 29
It always pays to use a quality Ultramarine. Inferior
versions will not give clear, even layers when
applied thinly due to an excess of filler.

The colors suggested on this and the next page have been carefully
selected to give as wide a range of lightfast colors as possible.
School of Color paints were used to prepare the color mixes but
any brand can be used. Do bear in mind however, that different
makes tend to vary somewhat in color. One manufacturers'
Cadmium Yellow Light, for example, might be brighter and more
orange than another. As this book is intended to be a guide this
should not present a problem.
It would be impossible to cover all variations.

YELLOW OCHRE

NEUTRALISED ORANGE-YELLOW,
SEMI-OPAQUE
LIGHTFASTNESS I: EXCELLENT
P.Y. 43
A good quality Yellow Ochre will cover well, (semi-opaque) but also give quite clear thinner layers.

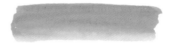

RAW SIENNA

NEUTRALISED ORANGE-YELLOW,
SEMI-TRANSPARENT
LIGHTFASTNESS I: EXCELLENT
P.Br. 7
Look for the ingredients 'P.Br 7 Raw Sienna' as this color is often imitated.

PHTHALOCYANINE BLUE

GREEN-BLUE, TRANSPARENT
LIGHTFASTNESS II: VERY GOOD
P.B.15
Prussian Blue could be used as an alternative to Phthalocyanine Blue as it is similar in hue, transparency and strength.

PHTHALOCYANINE GREEN

MID-GREEN, TRANSPARENT
LIGHTFASTNESS I: EXCELLENT
P.G. 36
Viridian would be a suitable alternative as it is similar in color, transparency and strength to Phthalocyanine Green.

BURNT SIENNA

NEUTRALISED ORANGE, TRANSPARENT
LIGHTFASTNESS I: EXCELLENT
P.Br. 7
As with all transparent colors it pays to use a good quality as inferior versions often contain an excess of filler.

WHITE, OPAQUE

TITANIUM WHITE
LIGHTFASTNESS I: EXCELLENT
P.W.6
Choose your white according to appropiate media.

The pigment/s used in a paint can be identified by what is known as the 'Color Index Name'
For example, the pigment used in genuine Phthalocyanine Green (above) is P.G. 36.
This stands for 'Pigment Green 36'.

Although the mixes shown in the book are produced from just 11 colors, 12 are mentioned on the cover as you may choose to use white to create your tints when actually mixing the colors.
Please see page 5

Hansa Yellow and Cerulean Blue

A range of bright greens which vary in transparency from the semi transparent green-yellow to the opaque green-blue. Why buy pre-mixed greens when they are so easy to prepare?

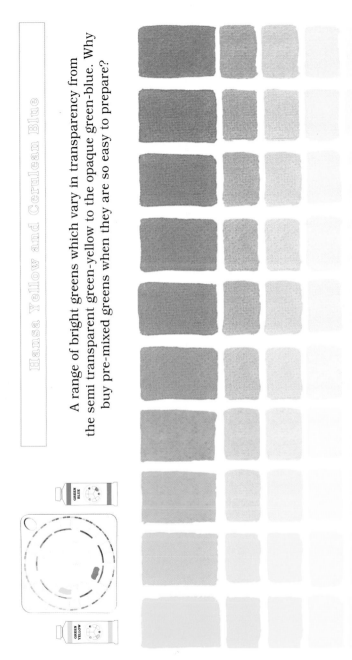

Hansa Yellow and Ultramarine Blue

Useful mid intensity greens. As the yellow is semi-transparent and the blue is very transparent, the tints will be particularly clear. Green-yellow to violet-blue.

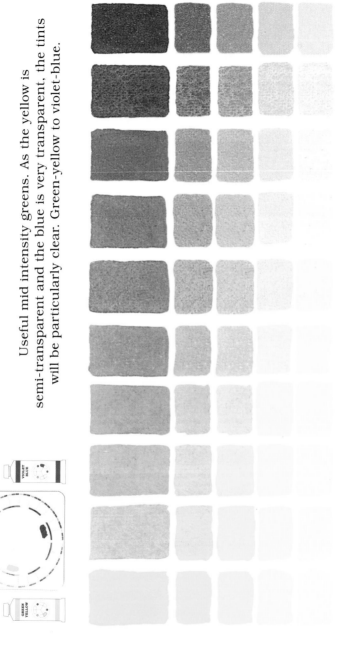

VIOLET
BLUE

GREEN
YELLOW

Further mid intensity greens. Both the yellow and the blue are opaque. At full strength the mixes cover well but tend to lose clarity when thinly applied due to the opacity of the contributing colors.

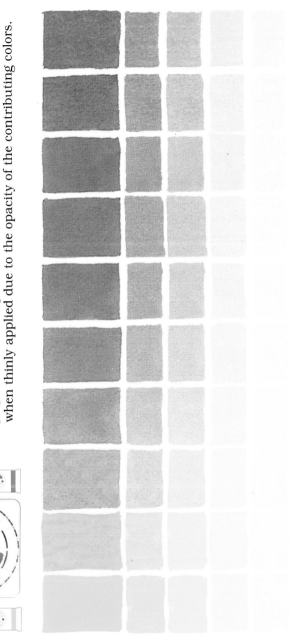

The greens vary from dull opaque yellow greens to dulled semi transparent blue greens. A range of very useful landscape colors. An ideal way to mix deep, subdued greens.

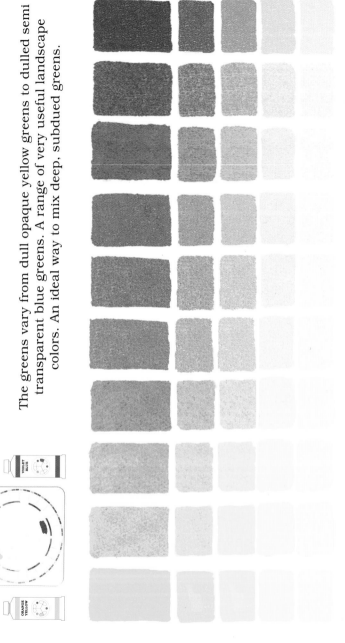

Hansa Yellow and Phthalocyanine Blue

A range of clear bright greens which will be more intense in paint form than shown printed here. Semi-transparent green-yellow to very transparent green-blue. The tints will wash out very thinly.

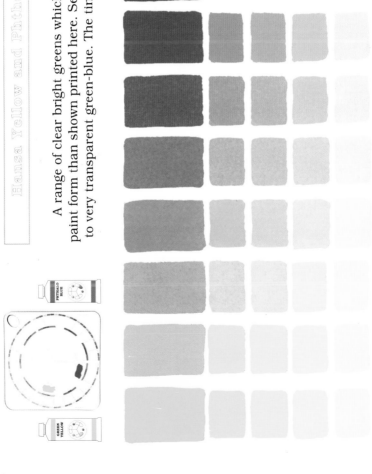

PHTHALO BLUE

GREEN YELLOW

Hansa Yellow and Phthalocyanine Green

From a semi-transparent green-yellow to the very transparent Phthalocyanine Green. A valuable range of clear, very bright greens. Phthalocyanine Green is very intense and should be used with care.

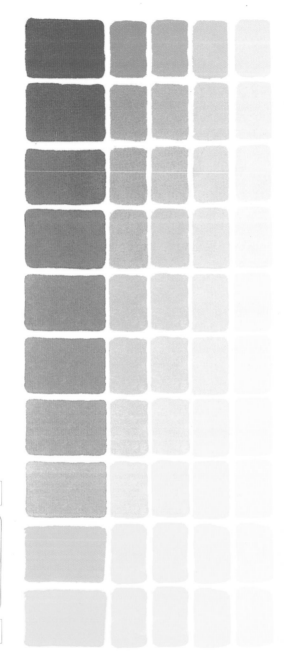

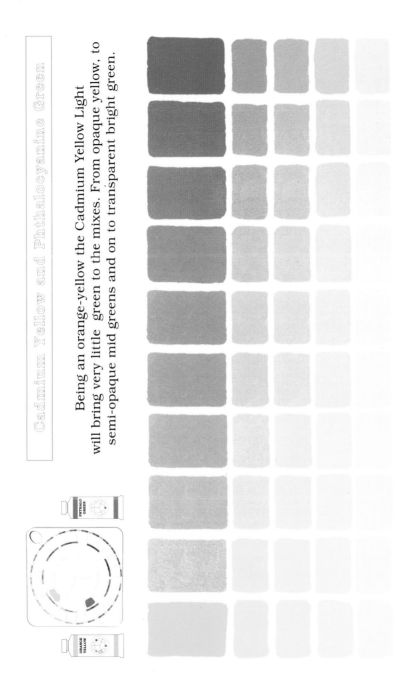

Being an orange-yellow the Cadmium Yellow Light
will bring very little green to the mixes. From opaque yellow, to
semi-opaque mid greens and on to transparent bright green.

PHTHALO GREEN

ORANGE YELLOW

Cerulean Blue and Phthalocyanine Green

As the blue is opaque and the green very transparent these mixes will change in opacity, becoming more transparent towards the green end of the range. An important factor in color use.

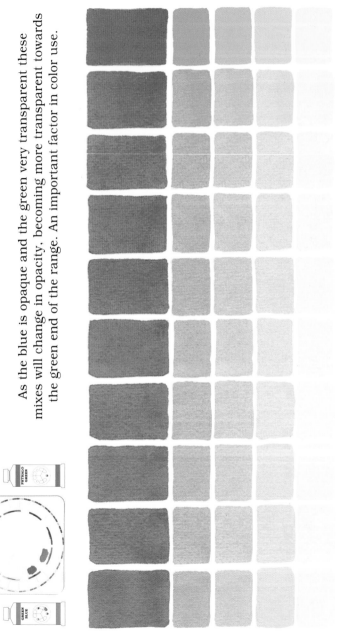

Ultramarine Blue and Phthalocyanine Green

As both colors are very transparent the mixes will give particularly clear tints. A range of slightly subdued blue greens with many applications, particularly in seascape painting.

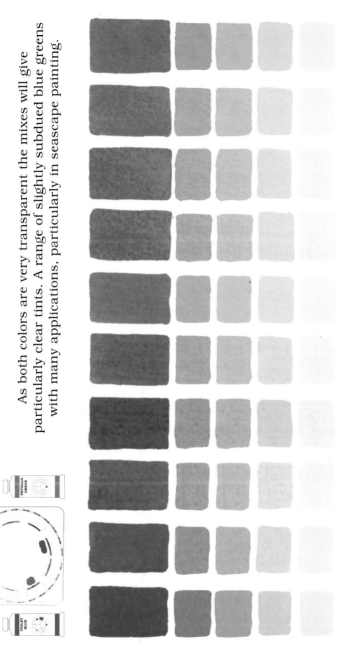

Very deep, blackish greens emerge from these two poor 'carriers' of green. In thinner applications these hues give a series of very subtle tints. Such colors are difficult to reproduce conventionally.

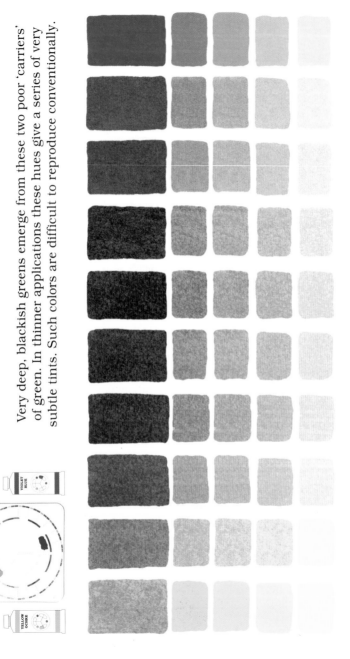

Raw Sienna and Ultramarine Blue

Raw Sienna is a soft neutral orange-yellow varying between transparent and semi-transparent. Very soft greens emerge from these two hues which are particularly useful in glazing.

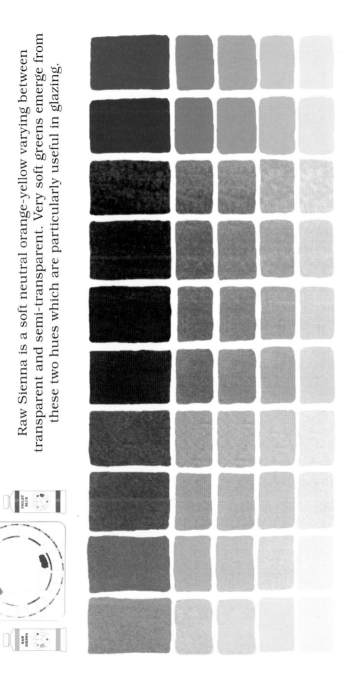

Phthalocyanine Green and Phthalocyanine Blue

For the brightest possible mixed transparent greens. Intense colors which give very clear tints when lightly applied. Both colors are strong and should be used with care when mixing with other hues.

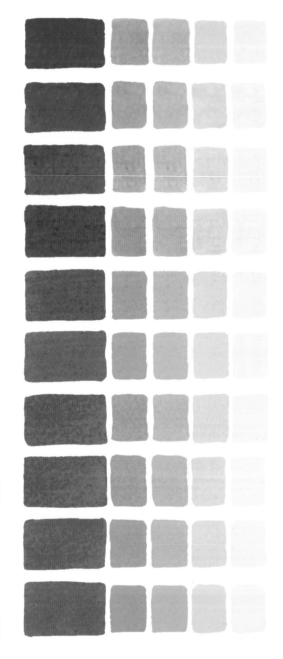

Quinacridone Violet and Phthalocyanine Green

As both contributing colors are transparent and also mixing complementaries, expect very dark 'colored grays' around the middle of the range when the mixes are at all heavily applied.

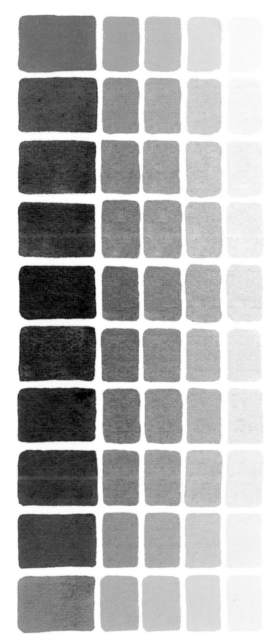

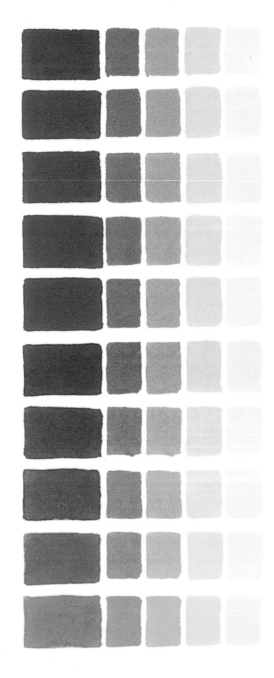

Quinacridone Violet and Ultramarine Blue

Red to blue violets; bright, strong and very transparent, the brightest lightfast violets that can be mixed. The results will be much duller and will turn bluer as the red fades if you use unreliable Alizarin Crimson.

VIOLET BLUE

VIOLET RED

Cadmium Red Light and Ultramarine Blue

A range of mid intensity violets will emerge as these two are mixed as only the blue is a good 'carrier' of violet. The blends will vary in opacity from the opaque red to the transparent blue.

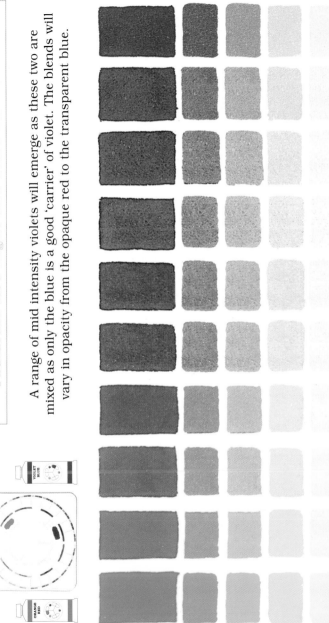

Further mid intensity violets. This time only the red 'carries' a useful 'amount' of violet, the blue reflects very little. From transparent violet red to opaque green-blue.

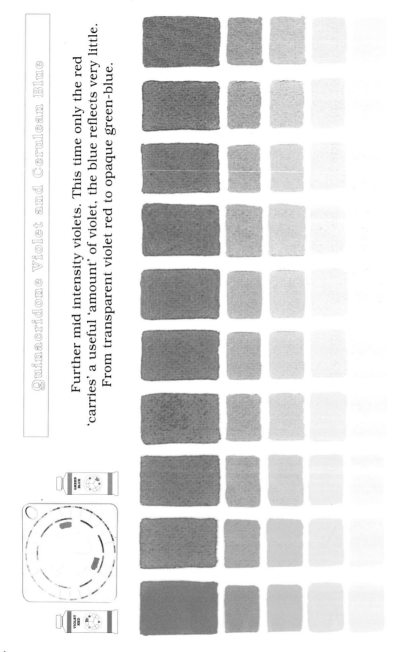

Dulled violets around the middle of the range with subdued orange reds and green-blues at either end. As both colors are opaque the full strength mixes will cover other colors very well.

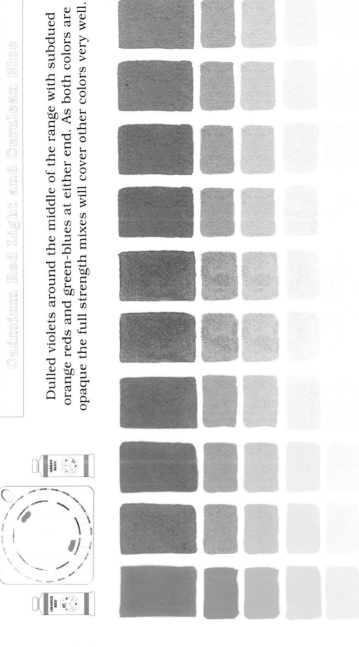

Cadmium Yellow Light and Cadmium Red Light

Bright yellow to red oranges. Both colors are strong and opaque, these qualities will be imparted to the mixes. The colors that you mix, if you select quality paints, will be slightly brighter than shown here.

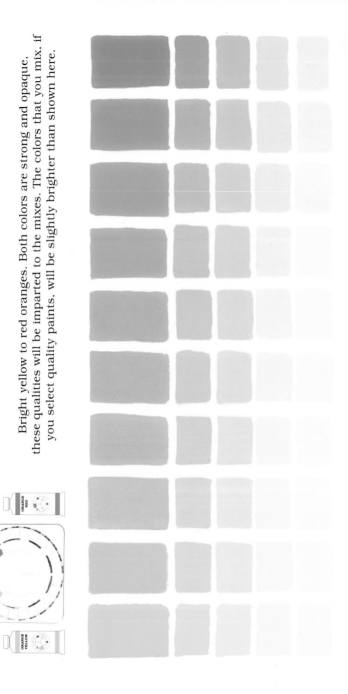

Useful mid intensity oranges. The red 'carries' most of the orange to the mix with the yellow providing very little. The blends will be neither dull or particularly bright.

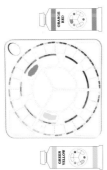

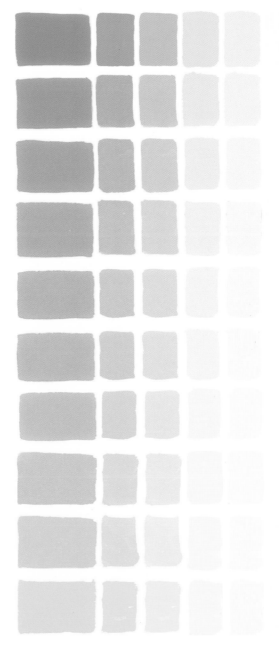

27

Cadmium Yellow Light and Quinacridone Violet

A valuable range of mid intensity oranges. As only the orange-yellow is an efficient 'carrier' of orange, the mixes will be neither dull or particularly bright. Opaque at the yellow end moving to transparent violet-red.

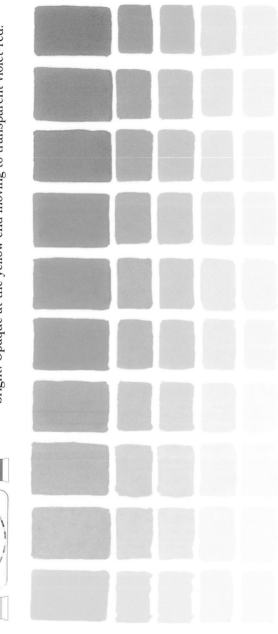

Hansa Yellow and Quinacridone Violet

From the semi-transparent green-yellow to the very clear violet-red, the mixes can be considered to be transparent. As neither color brings much orange to the mix the blends will be rather dull.

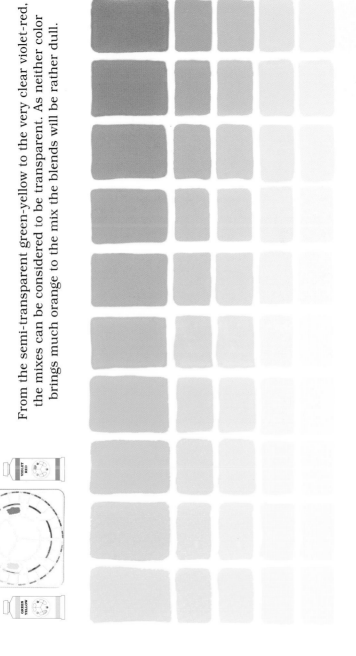

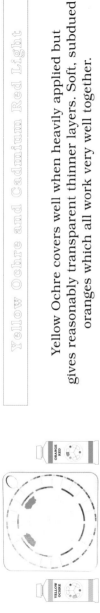

Yellow Ochre covers well when heavily applied but gives reasonably transparent thinner layers. Soft, subdued oranges which all work very well together.

ORANGE RED

YELLOW OCHRE

30

Mixing the greens for the following color swatches

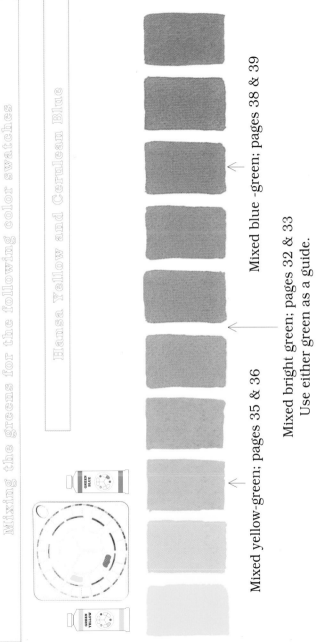

Hansa Yellow and Cerulean Blue

Mixed blue -green; pages 38 & 39

Mixed bright green; pages 32 & 33
Use either green as a guide.

Mixed yellow-green; pages 35 & 36

Please refer to page 9 (partly reproduced above) if you wish to mix the greens for the following color swatches. Do not try to match the colors exactly. In the first place you will be using paints and these are printed colors. In the second, this swatch book is intended as a color mixing *guide*, not as a exact color matching resource. Very close matching could only ever apply to one range of paints, would be prohibitively expensive to print and would still be far from exact. Please bear these factors in mind when working with this guide.

Cadmium Red Light and mixed bright green

As with all of the color ranges in this book, these hues can be made to harmonise with ease. Opaque orange-red to bright greens with very subtle 'colored grays' particularly when thinly applied.

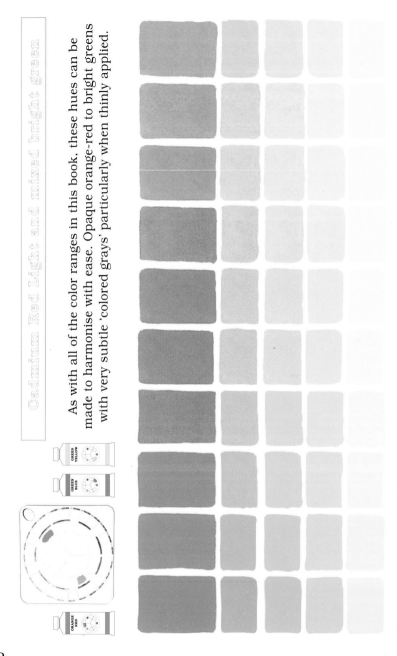

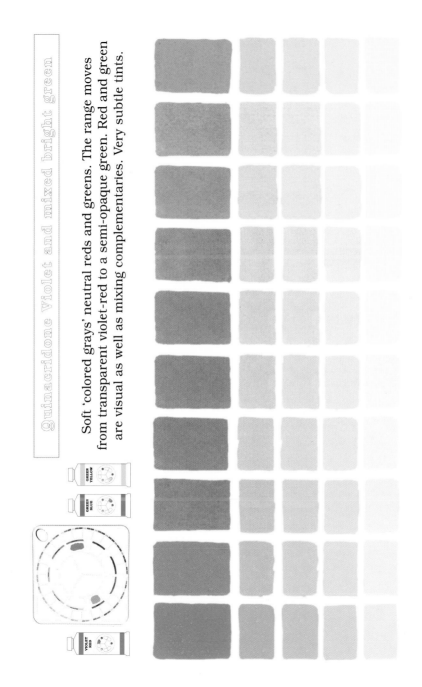

Quinacridone Violet and mixed bright green

Soft 'colored grays' neutral reds and greens. The range moves from transparent violet-red to a semi-opaque green. Red and green are visual as well as mixing complementaries. Very subtle tints.

GREEN YELLOW

GREEN BLUE

VIOLET RED

33

For those using our color coded mixing palette:

The outer ring of mixing wells are intended for those colors that you wish to neutralise (darken or make duller). To produce the yellow-green for the following two swatches, simply mix the green following the guidelines on page 31 and place it into the nearest outer well. As you will see, the outer wells are all color coded. As you will be mixing a bright, rather than a light or dark yellow-green, use the centre color on the well as your guidance. Do not try to match the color that you have mixed and the color printed on the palette. So many yellow-greens could be mixed that it would be impossible to have a well for each.

Mixed yellow green and Cadmium Red Light

As the mixed green can be considered to be semi-opaque, and the red is fully opaque, the mixes will cover well. If the fully saturated red and green are used sparingly, the entire range can be harmonised with ease.

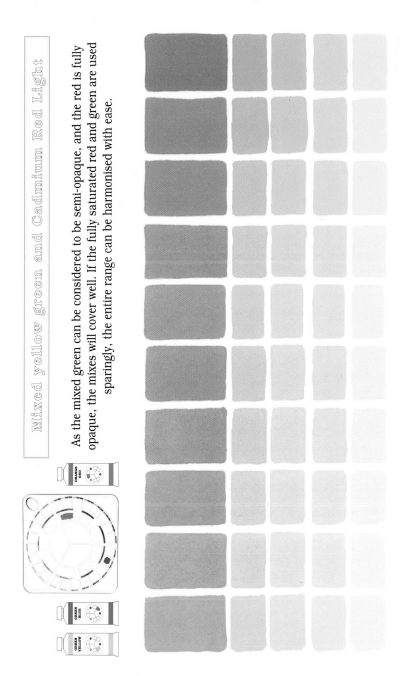

The mixed green will be relatively bright as the blue and yellow are both efficient carriers of green. Yellow-green and violet-red make a versatile mixing pair, giving a wide range of colors to work with.

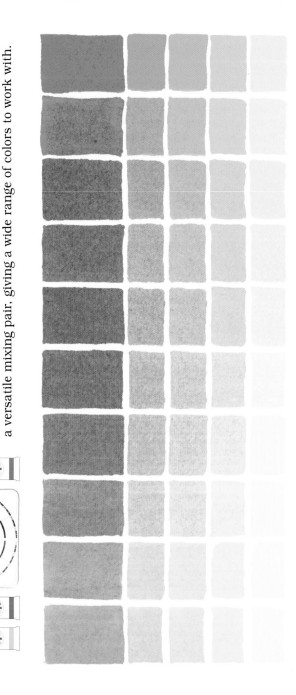

For those using our color coded mixing palette:

The outer ring of mixing wells are intended for those colors that you wish to neutralise (darken or make duller). To produce the blue-green for the following two swatches, simply mix the green following the guidelines on page 31and place it into the nearest outer well. As already mentioned, do not try to match the color that you have mixed and the color printed on the palette.

The palette has been designed to identify the mixing complementaries. These will always be found opposite each other. By placing the color into the nearest color coded well and looking to the opposite side of the palette you will see that the complementary of a blue-green is an orange-red.

37

Mixed blue green and Cadmium Red Light

A most useful complementary pair. They neutralise (dull) each other beautifully, give versatile 'colored grays' around the middle of the range and an extensive series of subtle tints.

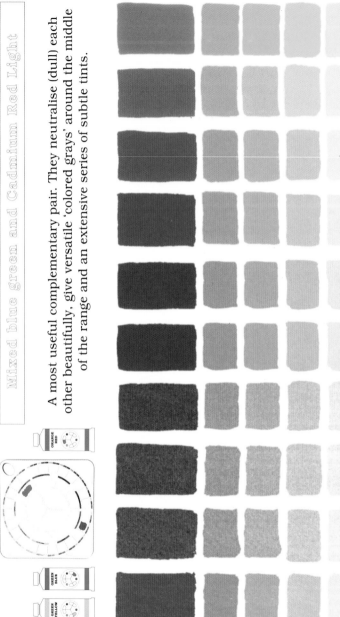

ORANGE RED

GREEN BLUE

GREEN YELLOW

38

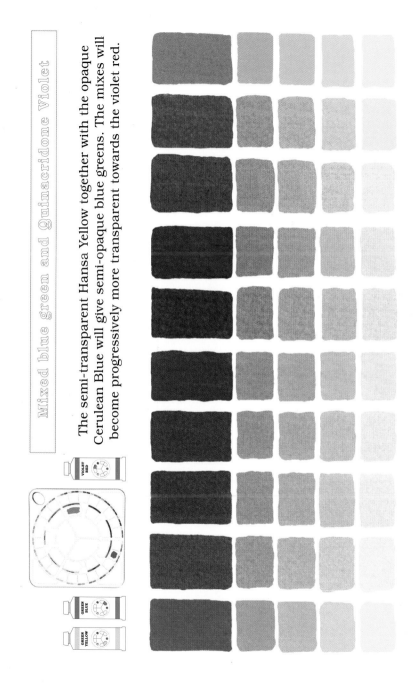

Mixed blue green and Quinacridone Violet

The semi-transparent Hansa Yellow together with the opaque Cerulean Blue will give semi-opaque blue greens. The mixes will become progressively more transparent towards the violet red.

VIOLET RED

GREEN BLUE

GREEN YELLOW

39

Quinacridone Violet and Ultramarine Blue

Mixed red-violet for further
experimentation

Mixed bright violet; pages 41 & 42
Use either violet as a guide.

Mixed blue-violet for further
experimentation

Please refer to page 22 (partly reproduced above) if you wish to mix the violets for the following color swatches. As has been mentioned, do not try to match the colors exactly. If you wish to experiment further, try adding red or blue-violet to either type of yellow (Hansa Yellow or the Cadmium Yellow Light).

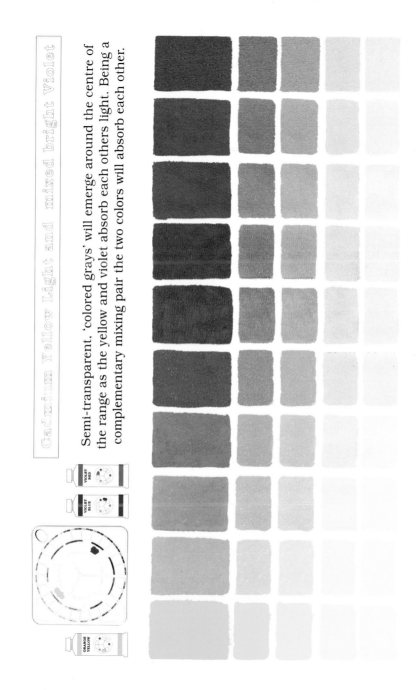

Cadmium Yellow Light and mixed bright Violet

Semi-transparent, 'colored grays' will emerge around the centre of the range as the yellow and violet absorb each others light. Being a complementary mixing pair the two colors will absorb each other.

Hansa Yellow and mixed bright Violet

As the yellow is changed from an opaque orange yellow to a semi transparent green-yellow, so the results will alter dramatically when compared to the mixes on the previous page.

VIOLET RED

VIOLET BLUE

GREEN YELLOW

Mixing the oranges for the following color swatches

Cadmium Yellow Light and Cadmium Red Light

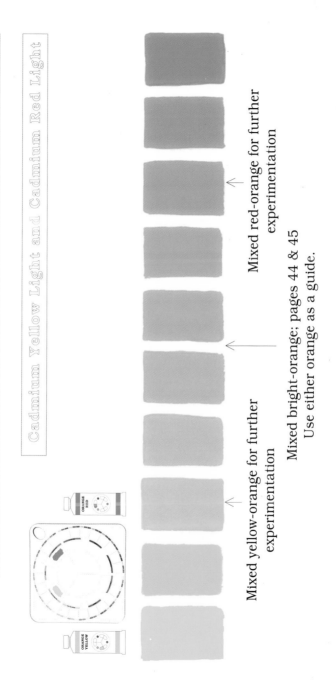

Mixed yellow-orange for further experimentation

Mixed bright-orange; pages 44 & 45
Use either orange as a guide.

Mixed red-orange for further experimentation

Please refer to page 26 (partly reproduced above) if you wish to mix the oranges for the following color swatches. As has been mentioned, do not try to match the colors exactly. If you wish to experiment further, try adding yellow-orange or red-orange to any of the blues, (Cerulean Blue, Ultramarine Blue or Phthalocyanine Blue).

43

As both the orange and blue are opaque, the mixes will cover other colors well. Subtle 'colored grays' and tints emerge around centre of the range. Invaluable 'colored grays' when mixed to order.

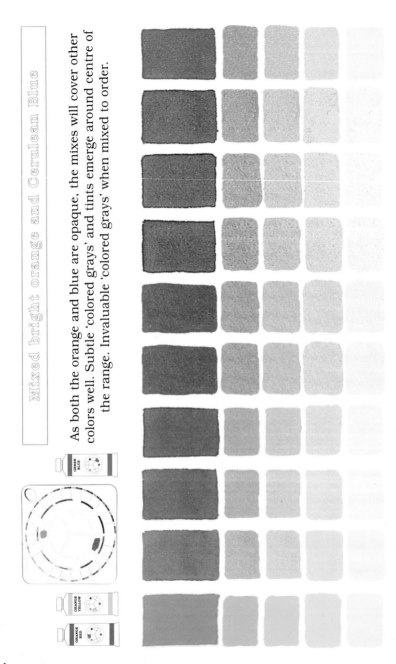

44

Mixed bright orange and Ultramarine Blue

Being a complementary mixing pair they will absorb each others' light. This leads to the dark 'colored grays' around the centre of the range. Such dark colors are invaluable when they can be produced to order.

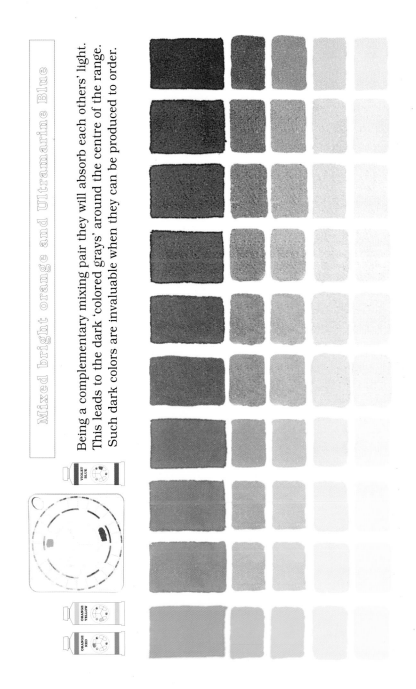

Cerulean Blue and Burnt Sienna

The 'colored grays' around the middle of the range will not be quite so dark as the mixes on the next two pages, because the Cerulean Blue is opaque and the mixes will absorb less light.

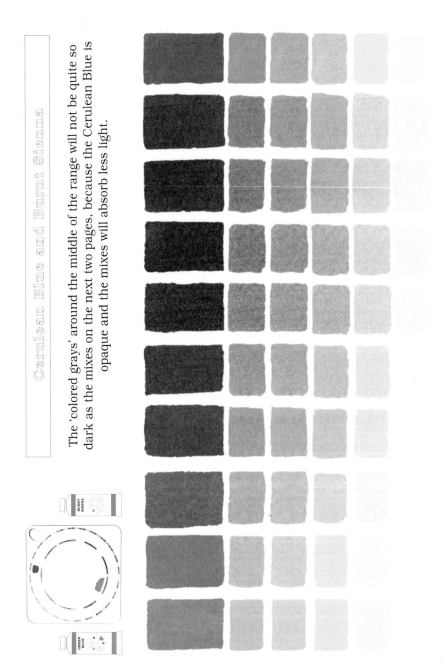

Phthalocyanine Blue and Burnt Sienna

A very useful range of transparent colors which can be harmonised with ease. Expect deep 'colored grays', almost blacks, as the two colors absorb each other and the light sinks in deeply.

Ultramarine Blue and Burnt Sienna

Being mixing complementaries the two colors will absorb each other, creating darks. As they are both transparent even more light will be lost. The ideal replacement for black, Payne's Gray and possibly Burnt Umber.

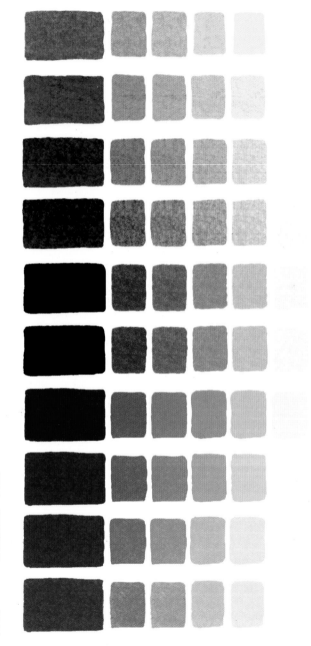

From the opaque green-blue (Cerulean Blue) to the transparent green blue, Phthalocyanine Blue, a superb range of 'sky' colors will emerge. Semi-transparent blues around the middle of the range.

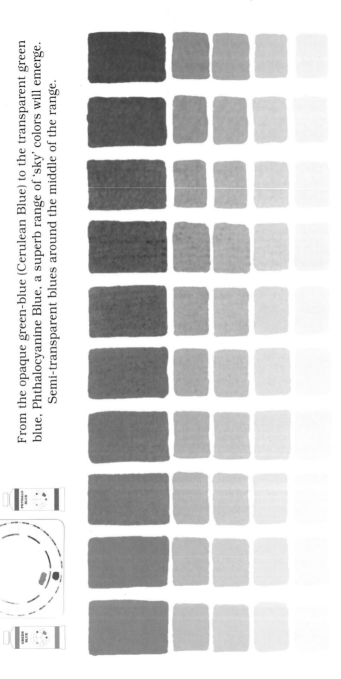

50

Phthalocyanine Blue and Ultramarine Blue

Transparent green-blue to transparent violet-blue. Many imitation Cobalt Blues (few are genuine nowadays) are produced from one or the other of these two, with the addition of white. A range of clear, bright blues.

51

The differences between the mixes will be very slight but they will extend your repertoire. Between the semi-transparent green-yellow (Hansa) and the opaque orange-yellow a versatile range will be available.

ORANGE YELLOW

GREEN YELLOW

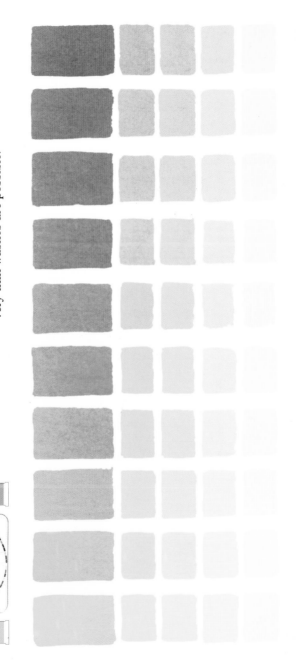

Hansa Yellow and Raw Sienna

A series of muted semi-transparent yellow oranges from this pair.
The full range can be harmonised with ease when working in monotone.
Very thin washes are possible.

RAW SIENNA

GREEN YELLOW

Cadmium Red Light and Quinacridone Violet

From opaque orange-reds moving through semi-transparent reds to transparent violet-reds. An invaluable range. You do not need to go out and buy every red in sight.

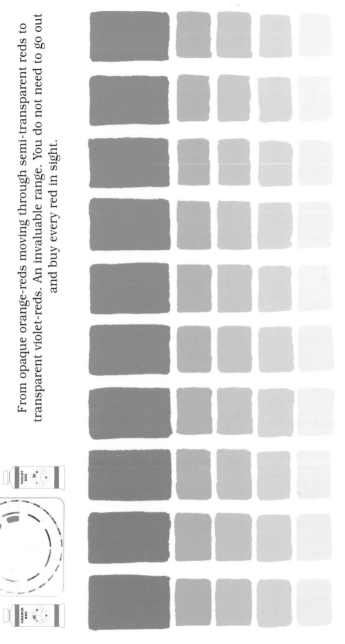

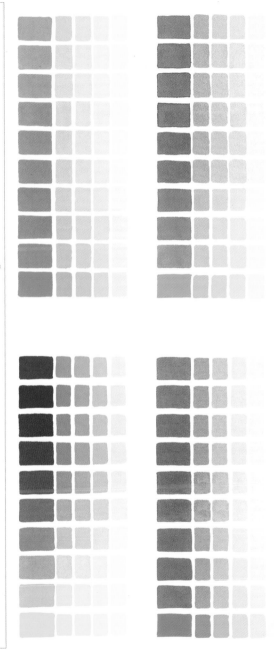

The easiest way to achieve color harmony is to work with a very limited number of colors. The fewer the better in almost every case. As each of the color swatches shown in the book are produced from no more than two colors, the hues on the entire page can be harmonised with ease. (The pre-mixed oranges, violets and greens can be considered a single color as they are easily reproduced). Each swatch will give a wide range with which to work, especially where the mixing complementaries have been used, yellow and violet, blue and orange and red and green. This is because 'colored grays' (the darks around the middle of the blend) will give a wider range of values to work with.

Mixing Greens

Mix any green that you require quickly and accurately - an artist's dream

Michael Wilcox

Depicting the Colors in

Water

From the sea, to a river to a puddle, mix the colors you need to depict water in all its moods - quickly and accurately

Craig Letourneau and Michael Wilcox

Depicting the Colors in

Trees and Bushes

Mix the varied hues of trees and bushes, quickly and accurately. A must for the landscape artist

Craig Letourneau and Michael Wilcox

Depicting the Colors in

Country and Coastal Cottages

Learn how mix the wide range of hues required for these timeless subjects

Craig Letourneau and Michael Wilcox

The Michael Wilcox

School of Color Publishing

Artist Quality products created by Artists

SCHOOL OF COLOR PUBLICATIONS

A range of products has been designed and books and courses published to help bring about a fuller understanding of color and technique. We offer paints, mixing palettes, books, courses, videos and workbooks.

For further information please contact any of the offices listed below:

The Michael Wilcox School of Color USA
25 Mauchly #328
Irvine
CA 92618 USA
Tel: 949 450 0266
Fax: 949 450 0268
Free Phone: 1888 7 WILCOX
e-mail: wilcoxschool@earthlink.net

The Michael Wilcox School of Colour UK
Gibbet Lane
Whitchurch, Bristol
BS14 0BX
United Kingdom
Tel: 01275 835500
Fax: 01275 892659
e-mail: wilcoxsoc@aol.com

The Michael Wilcox School of Colour Australia
PO Box 516
Wanneroo 6946
Western Australia
Tel: (61) 8 9405 6773
Fax: (61) 8 9306 9887
e-mail: wilcoxsoc@iinet.net.au

www.schoolofcolor.com